I like to think of Anthony Coleman's drawings as a pantheon of deities, a crossov
universe of characters worshiped through mass-consi
refigurations an act of love. Gumby, Spongebob, Carek
Man, C3PO, Flame — as rendered by Coleman, these
friends. That they are iconic, these superheroes and cc
by the way they're recognizable even when Coleman m
doing so he also makes them his own, and we sense that there's a deep connection
there, between the artist and subject, and we know so because we have it ourselves,
a feeling of intimacy with these pop figures, even if we share knowing them with
millions. With his idiosyncratic treatment, Coleman returns the aura to franchised
creations, works of art made grand in the age of mechanical reproduction, his small
colored-pencil drawings, a testament to how today pop is the raw material for lore.

There's a trope in dystopian narratives called "All Hail The Great God Mickey!"
Basically, our current society has fallen and whatever artifacts the reigning civilization
has found have been interpreted as having been made in the image of our divinities.
There's a meme forecasting that "someday future archaeologists are going to
dig up Disney World and think it was some bizarre mouse worshiping kingdom."
The steampunk fantasy *Mortal Engines* has monocled Victorian goths referring to
exhumed minion statuettes on a museum pedestal as "American deities." In *Babylon
5*, a poster of Daffy Duck is deciphered similarly. The point isn't that these fictional
future civilizations misinterpret us, it's that they got it right. There's a reason fandoms
are called cults.

I don't think it's dystopian, though, that we're constantly repurposing pop characters
as heuristic avatars. My best friend, Seashell Coker, has this Baby Nut plushie
displayed in her living room. To every new guest, she tells the story of the Planters
Peanuts Super Bowl commercial where the brand killed off their 104-year-old
mascot, only to have triggered so much blowback from the public that they
reincarnated their beloved anthropomorphic peanut as a new baby (one that sprouts
from the grave when the Kool-Aid Man's tear hits the fresh soil). I love hearing my
friend tell the tale over and over, a modern-day myth, her gloss woven into the oral
history, absurd and saying so much about our times. Cartoon characters mean a
lot to people. Brand mascots, superheroes, movie characters, celebrities, they're
all a part of a collective imaginary we use to talk about ourselves while building
on something shared. And as we see in the art of Anthony Coleman, sometimes
appropriating can be the most honest and original gesture.

— Whitney Mallett

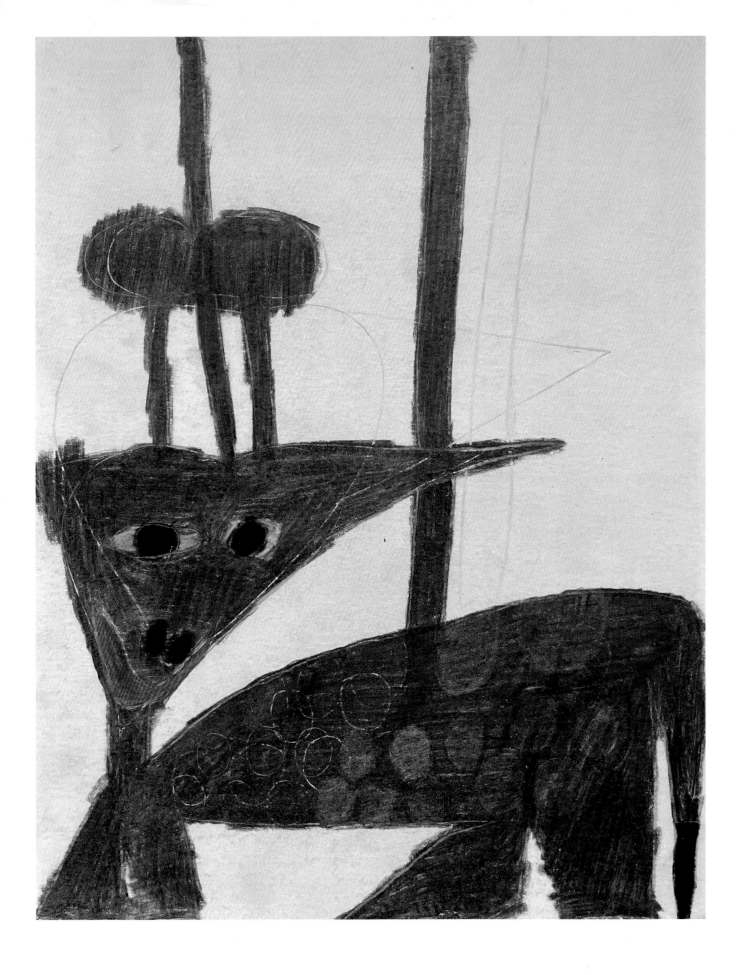

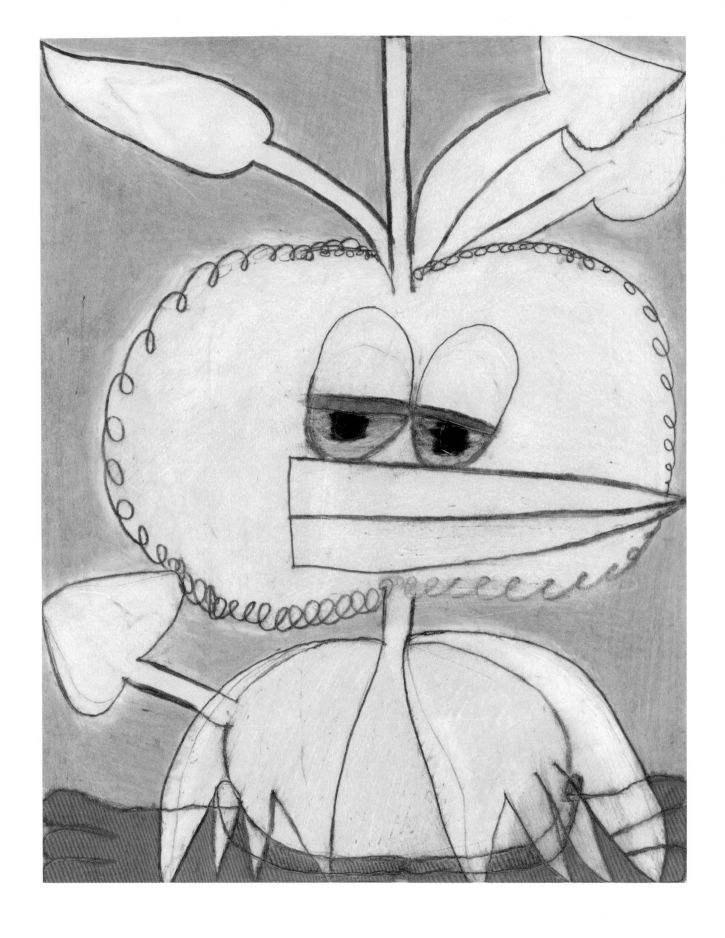

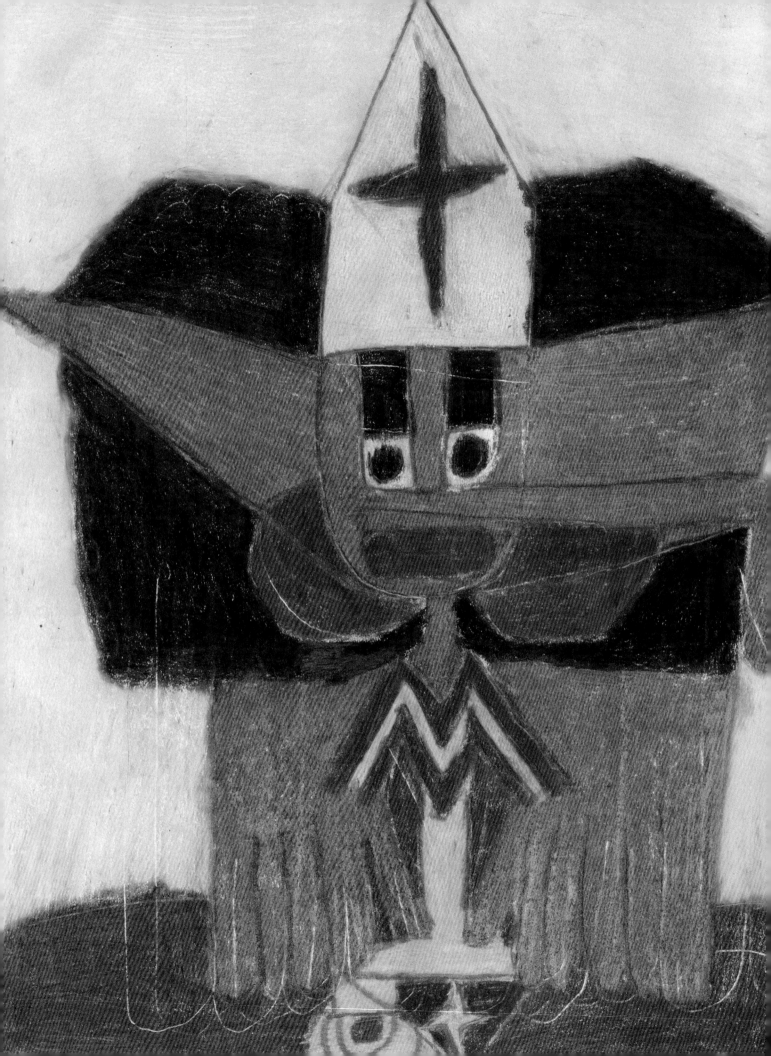

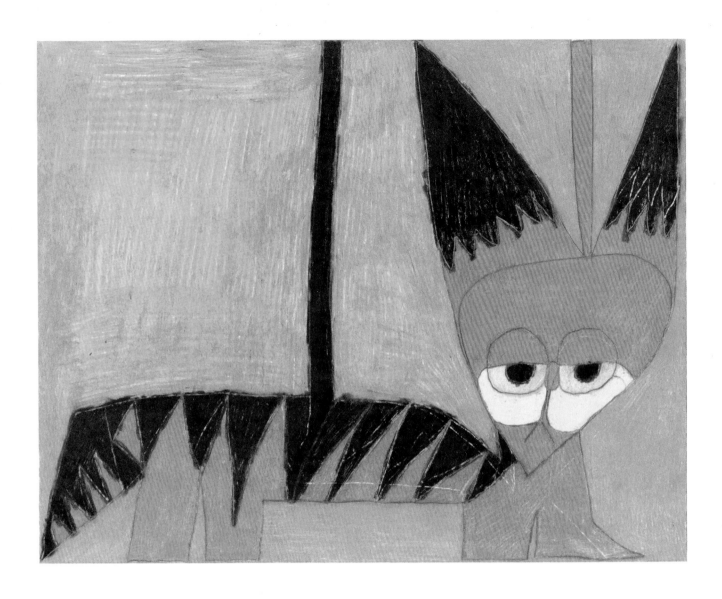

5

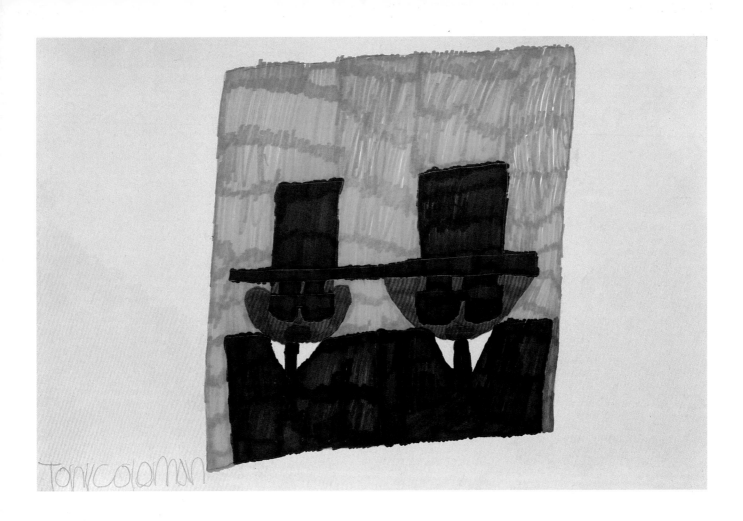

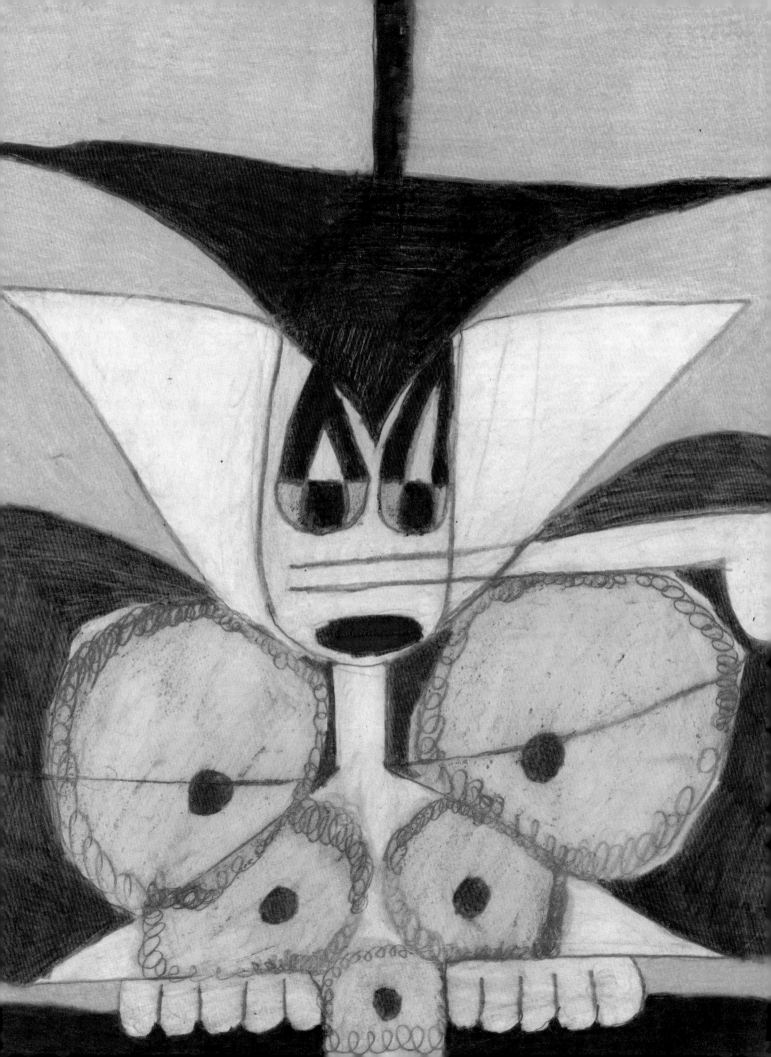

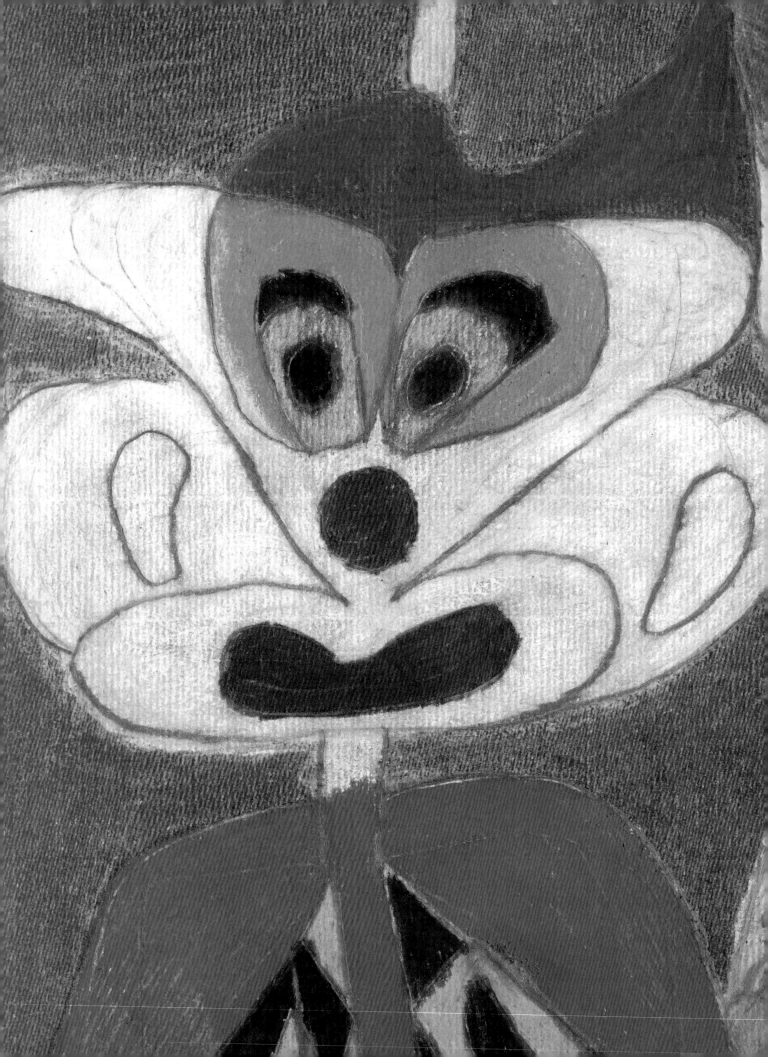

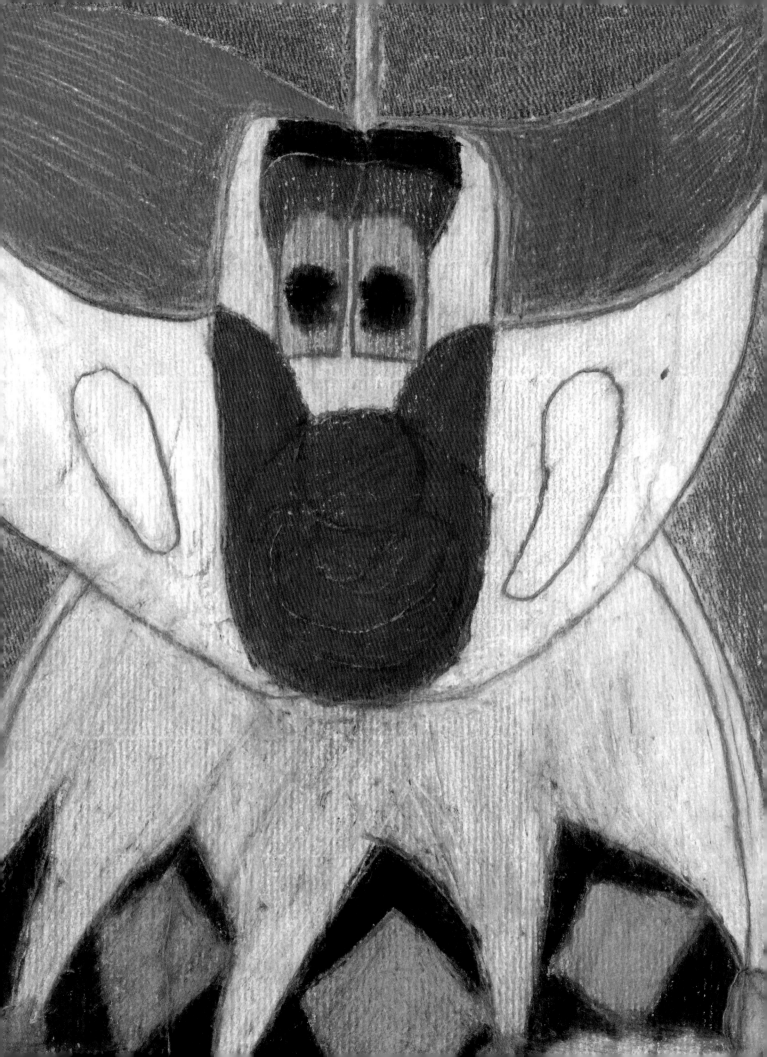

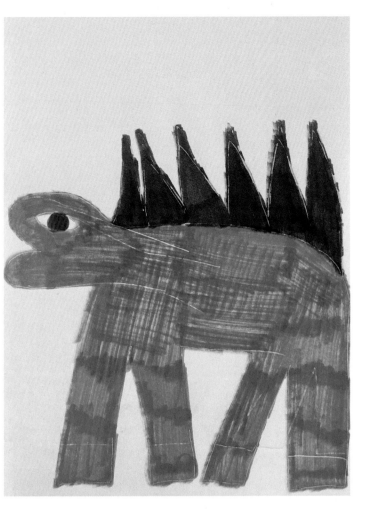
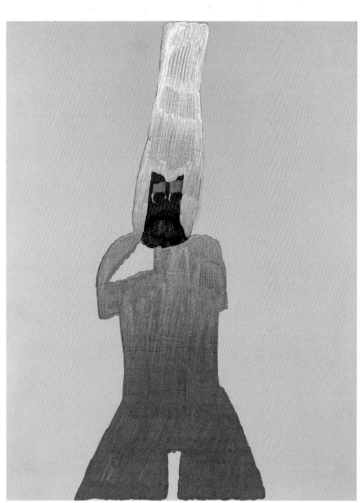
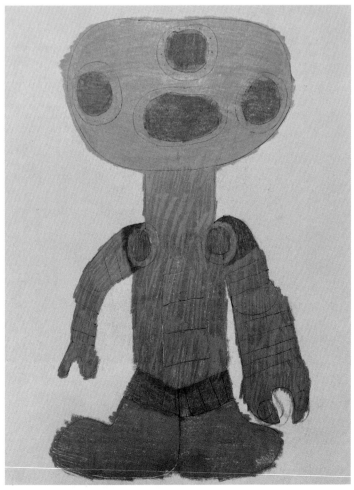
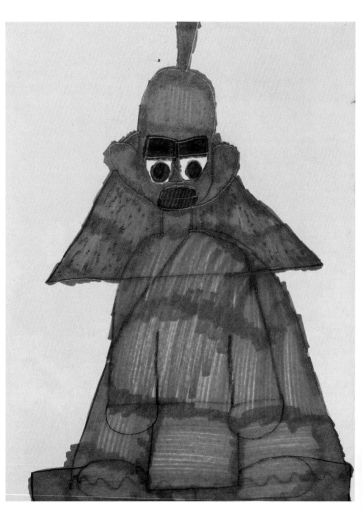

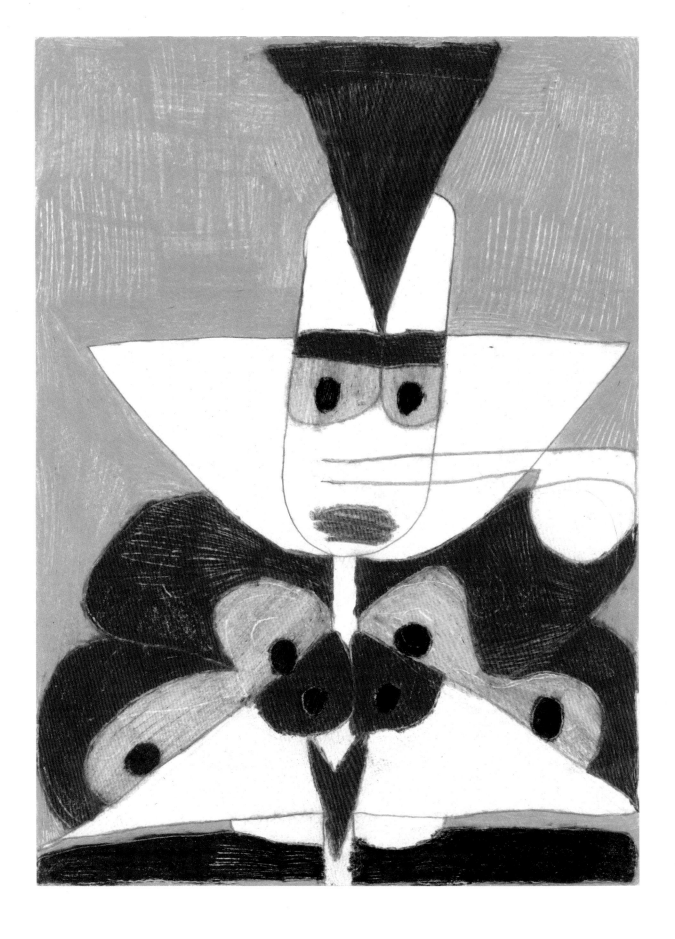

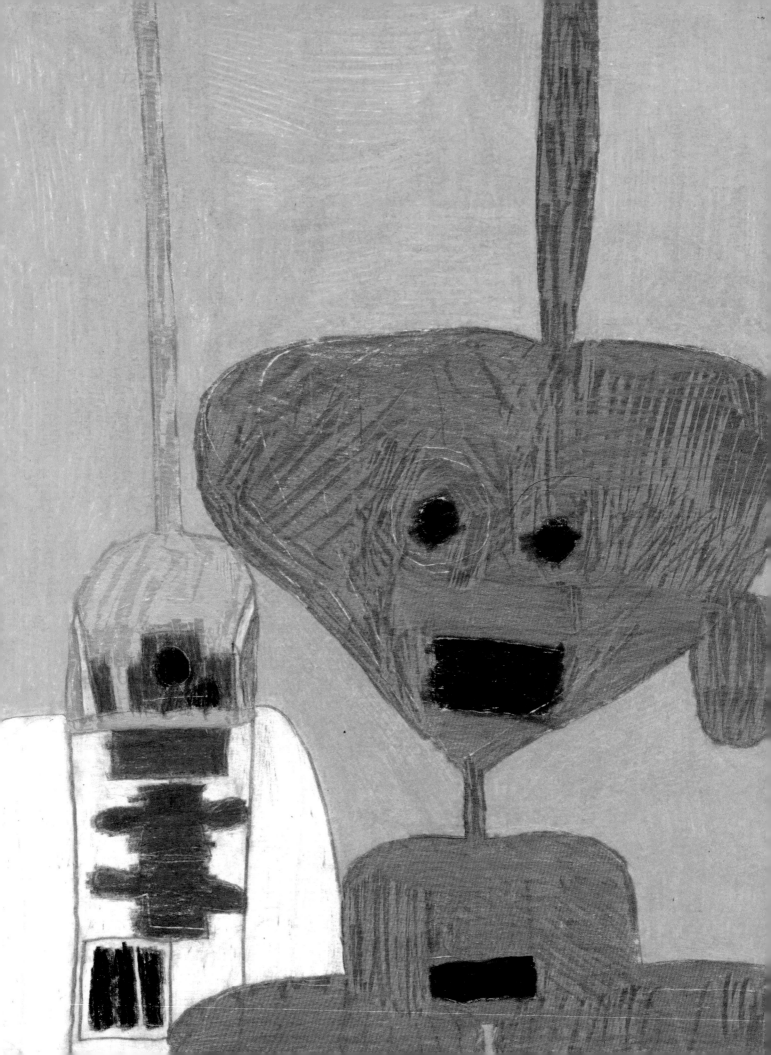

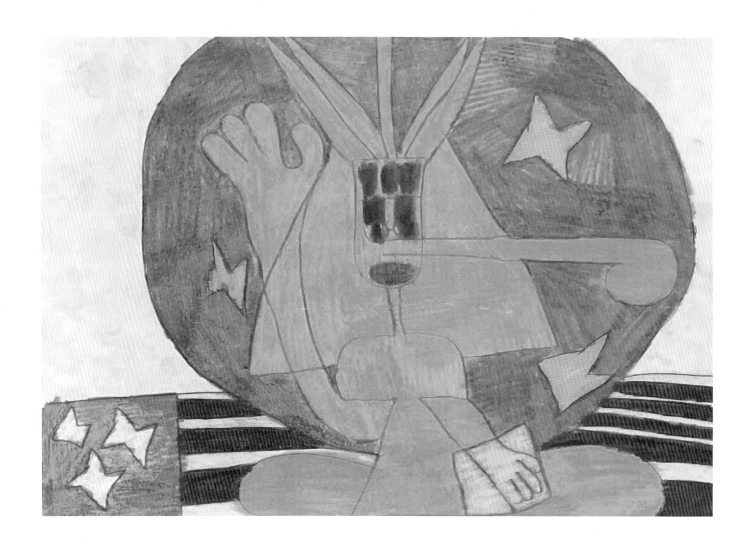

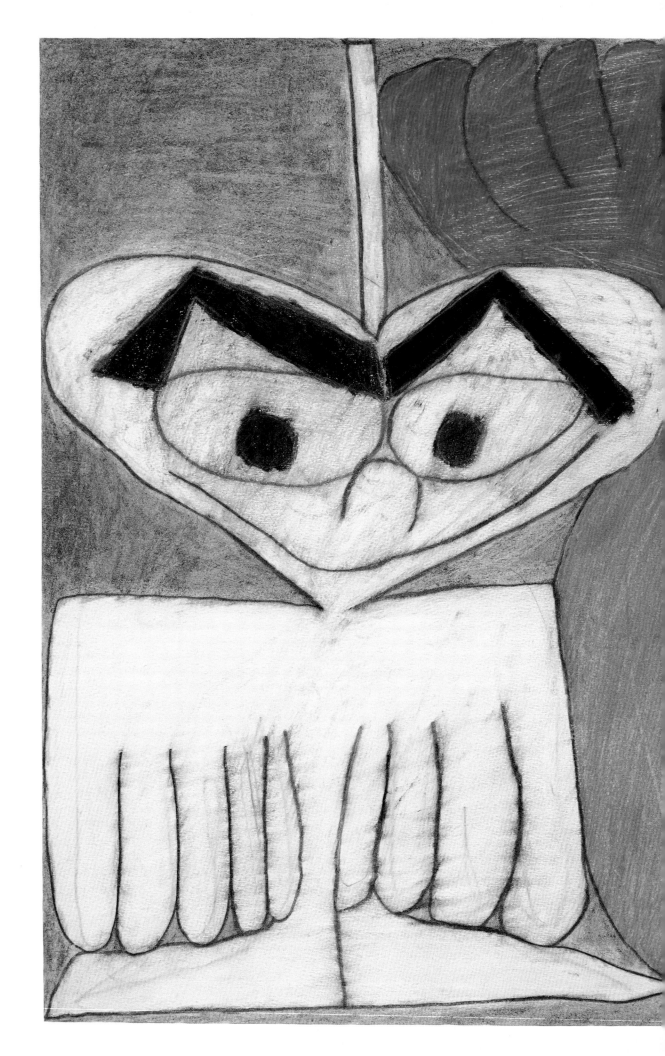

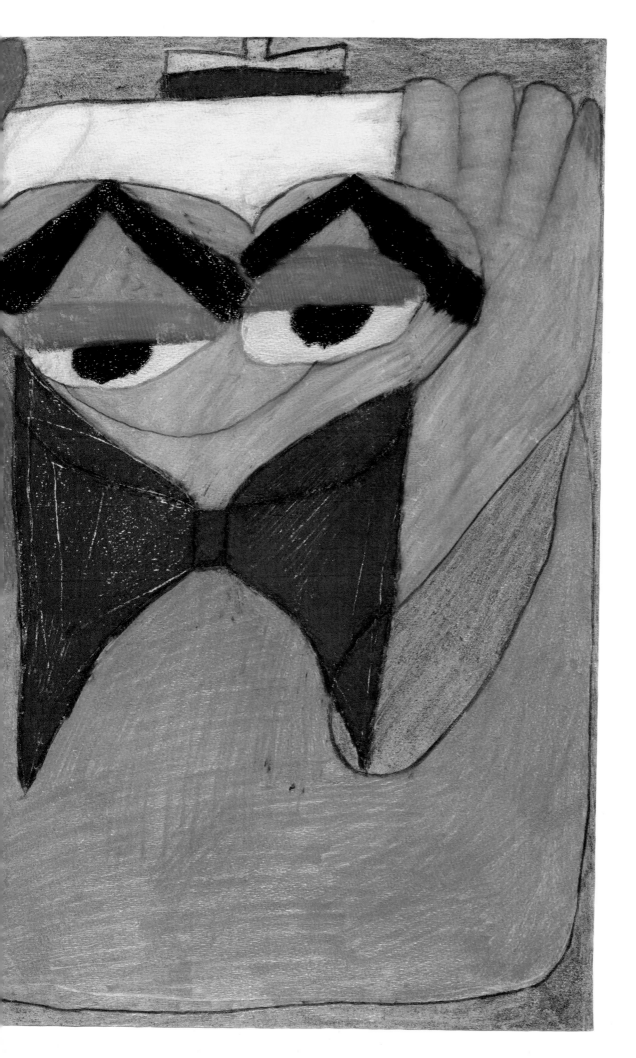

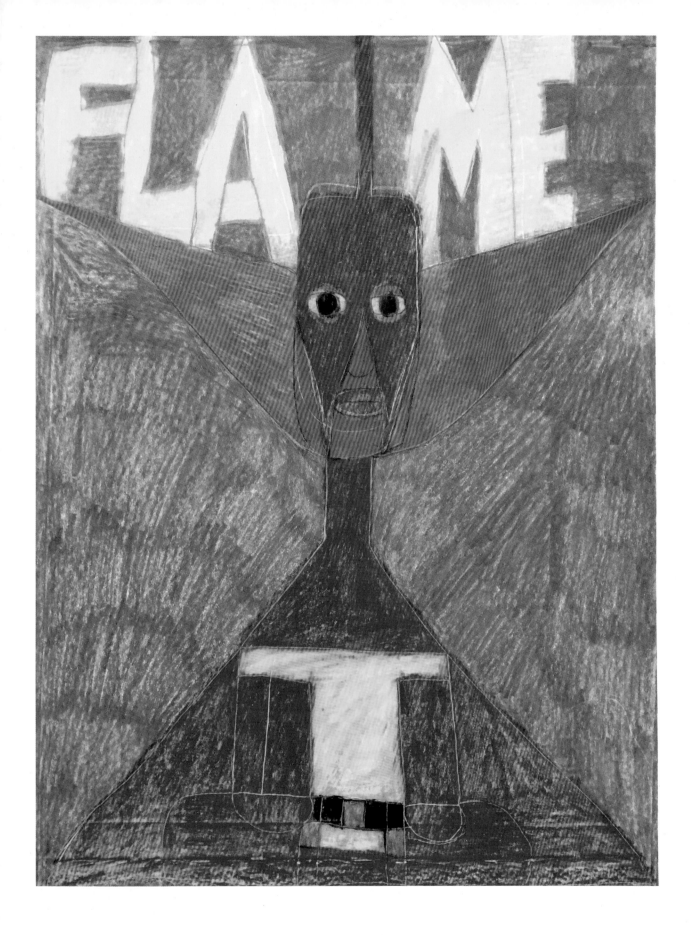

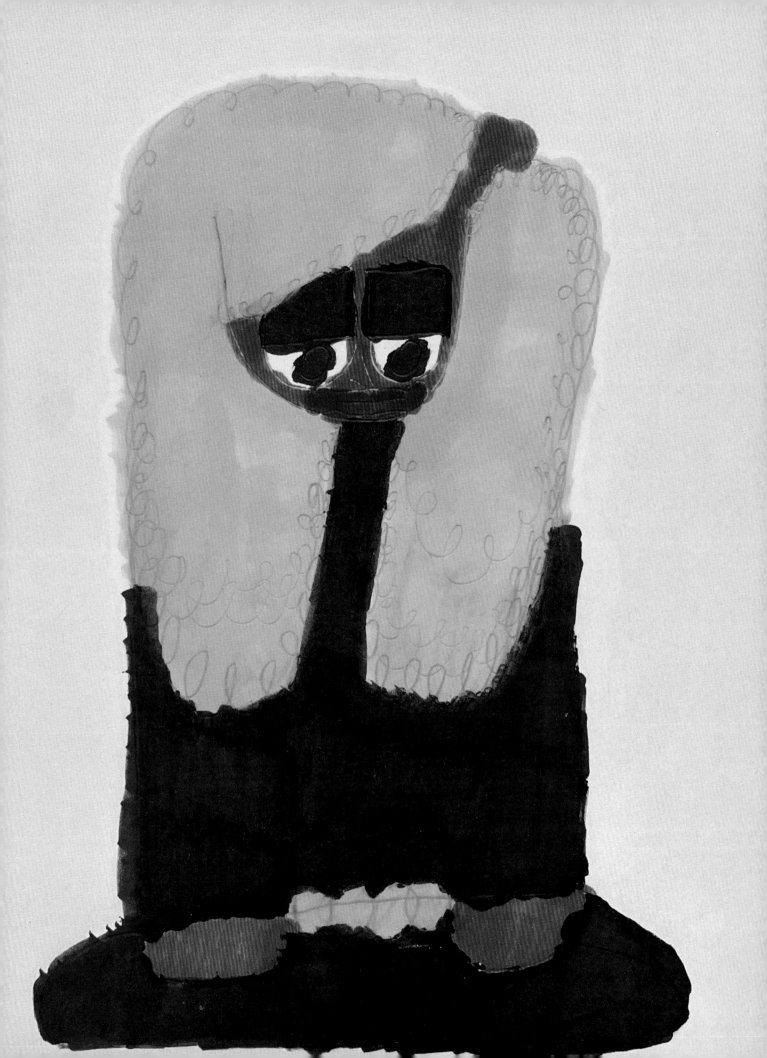

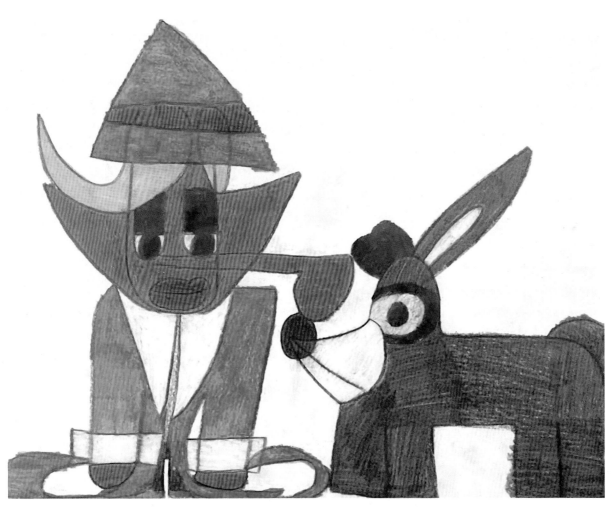

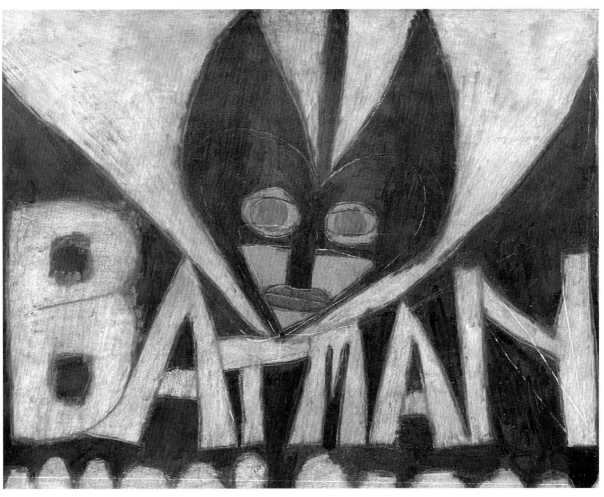

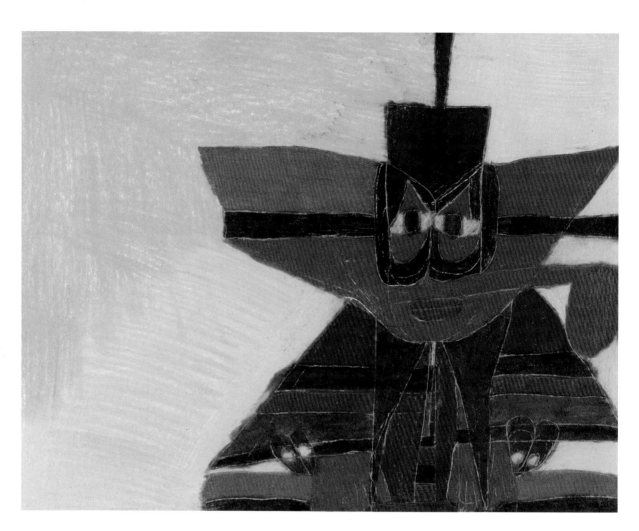

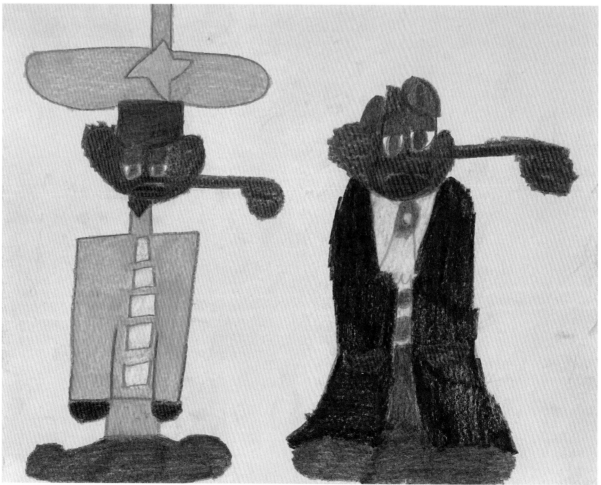

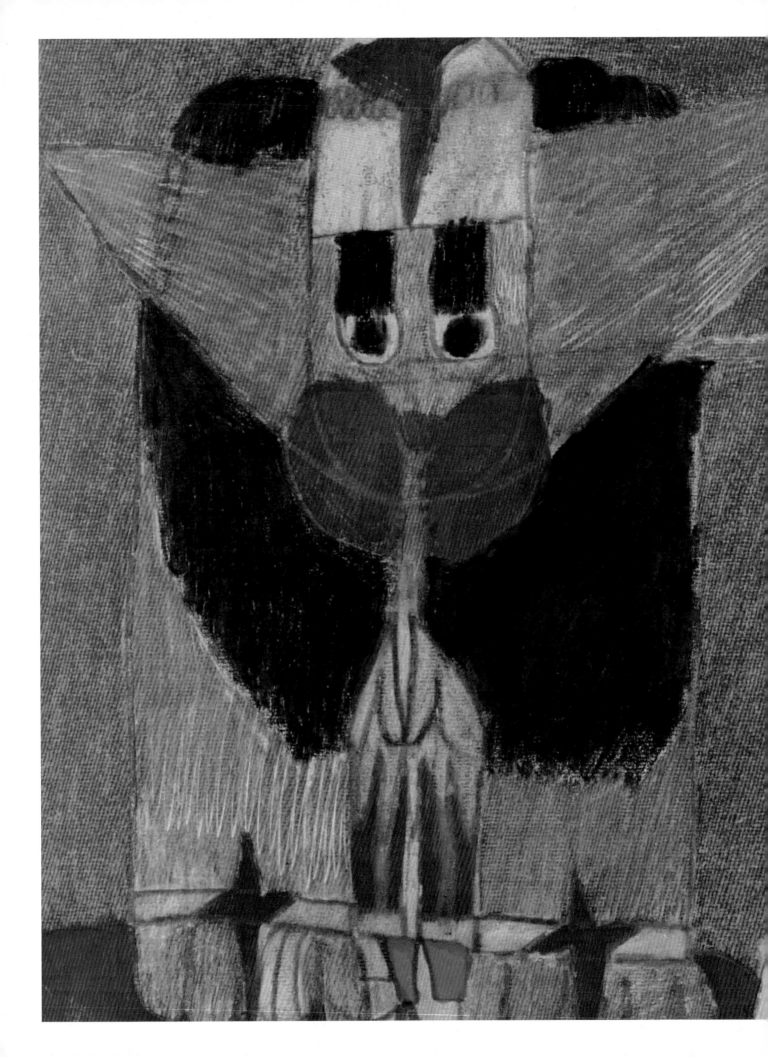

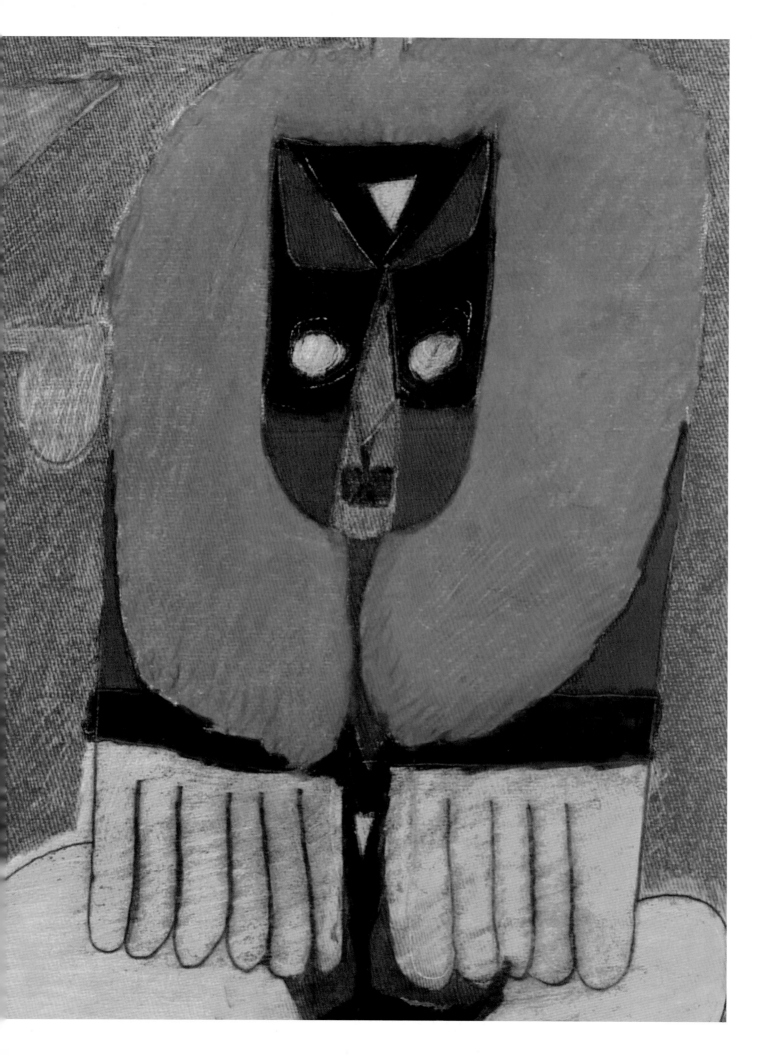

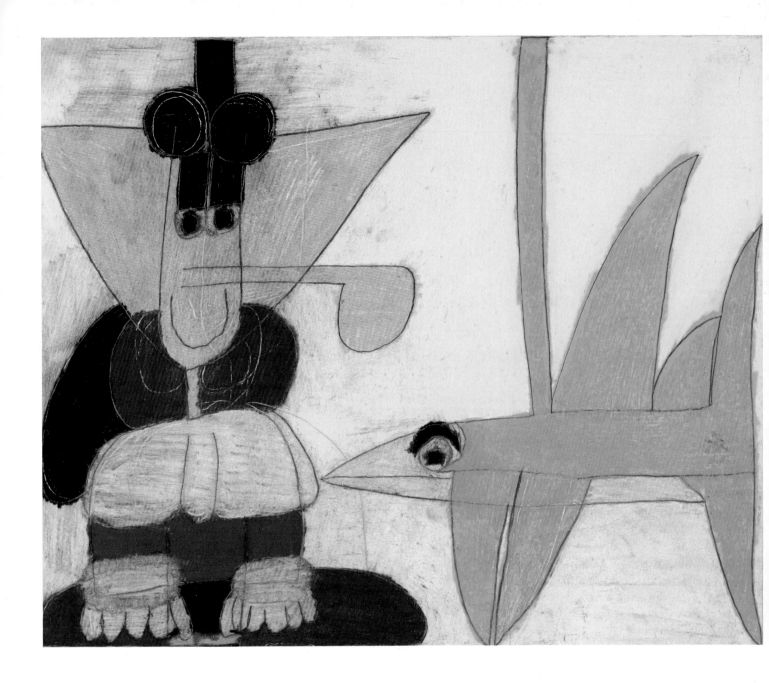

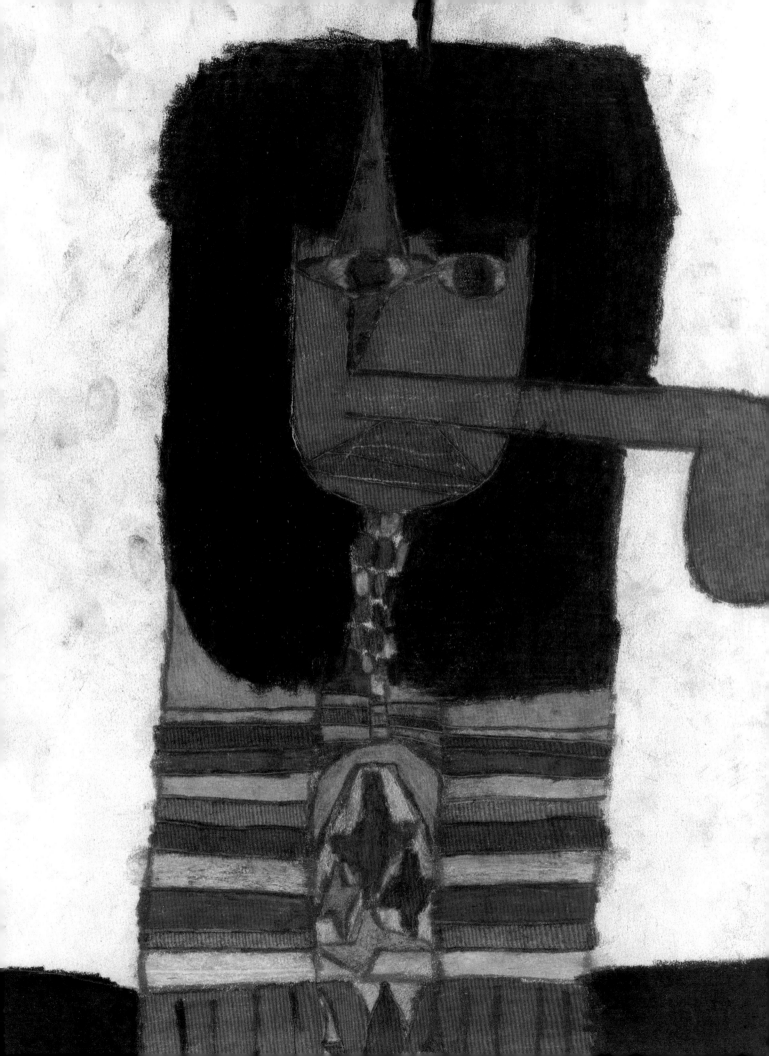

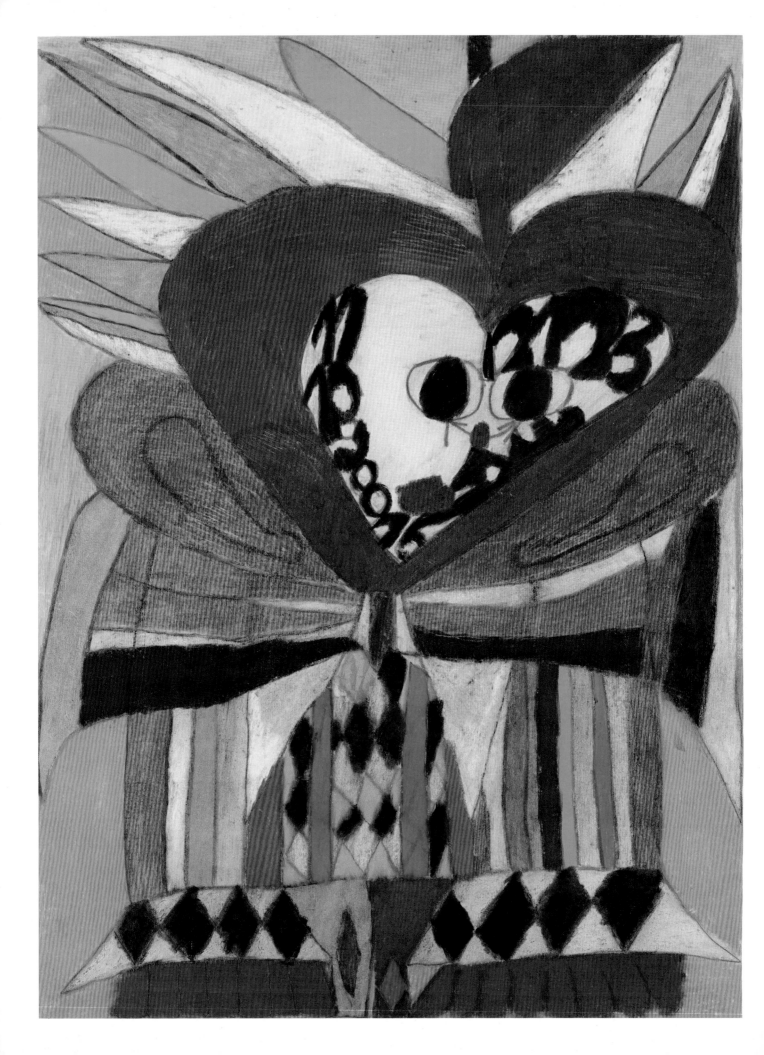

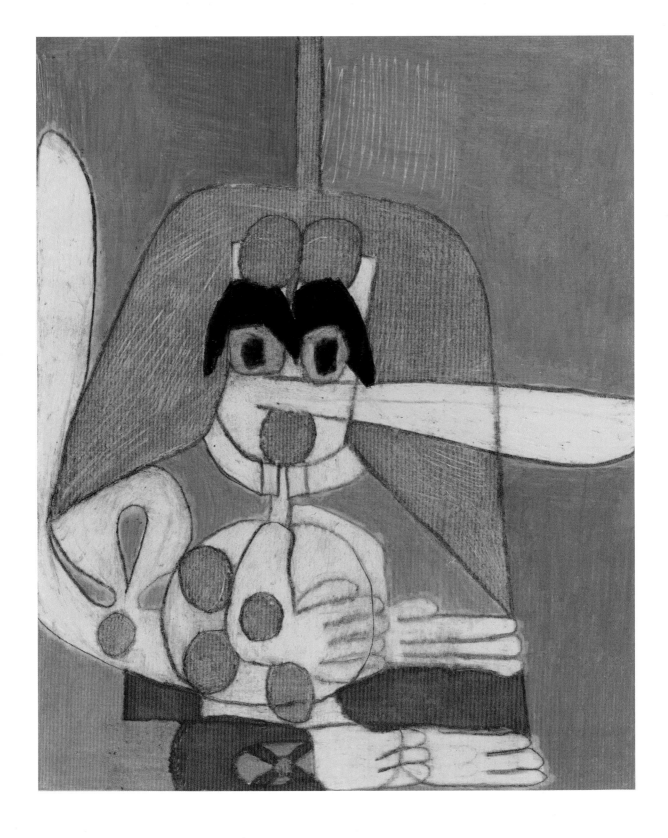

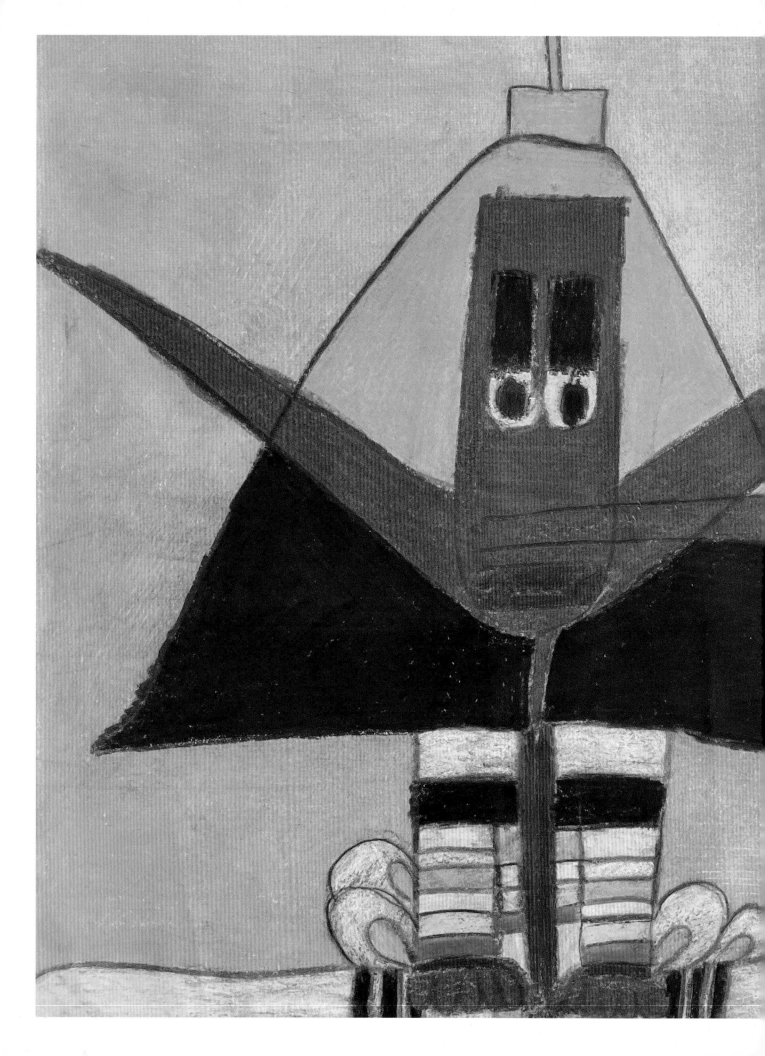

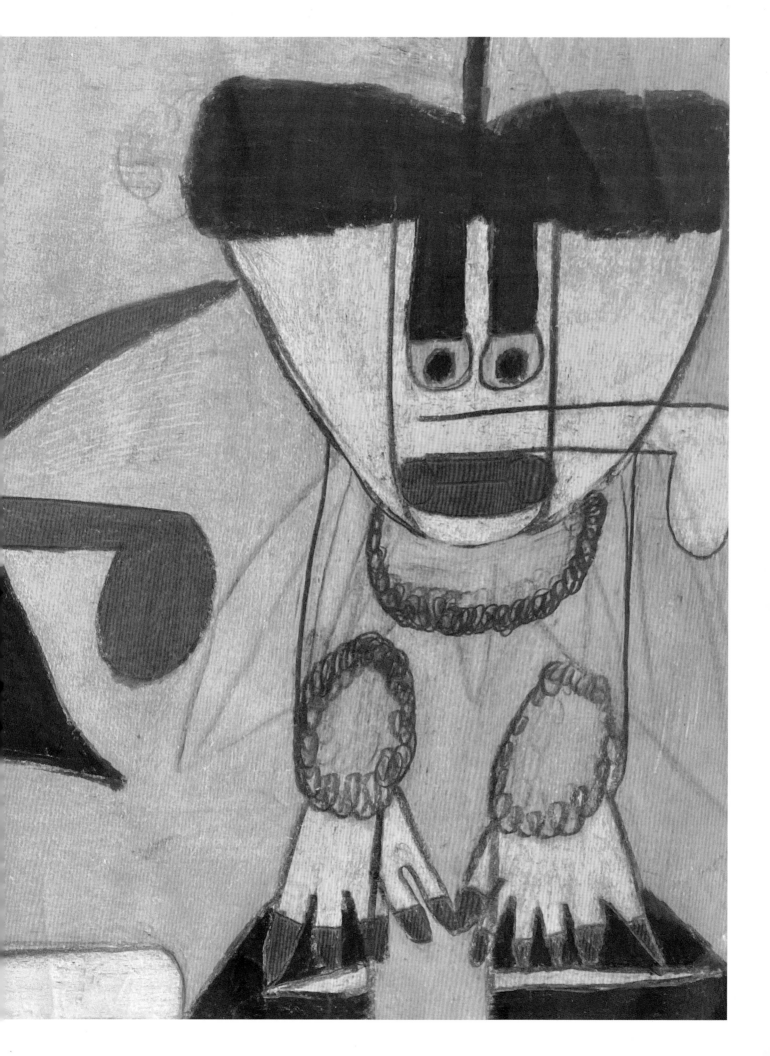

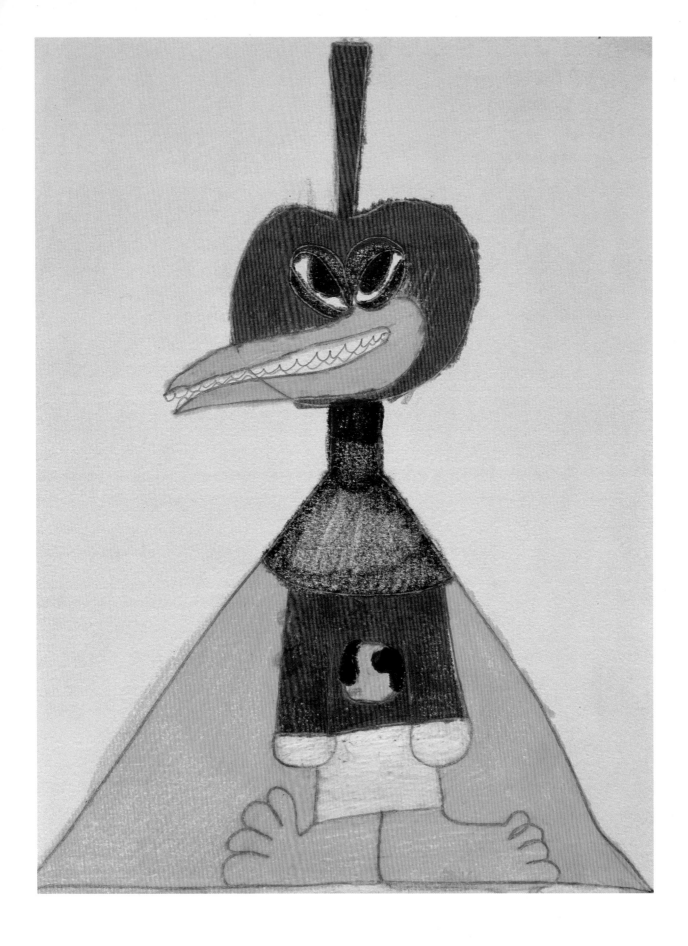

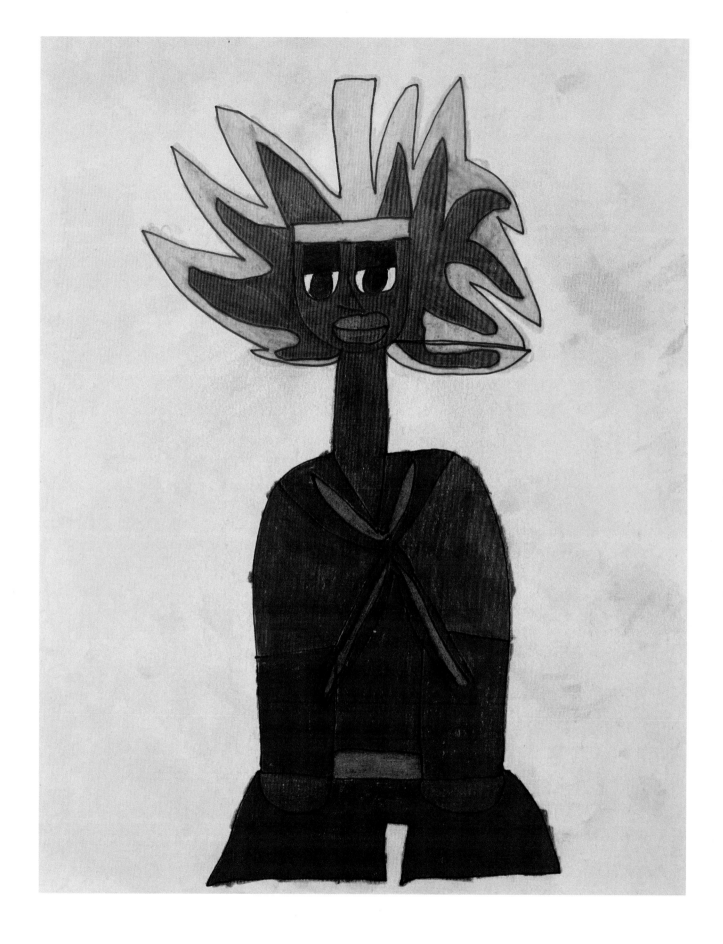

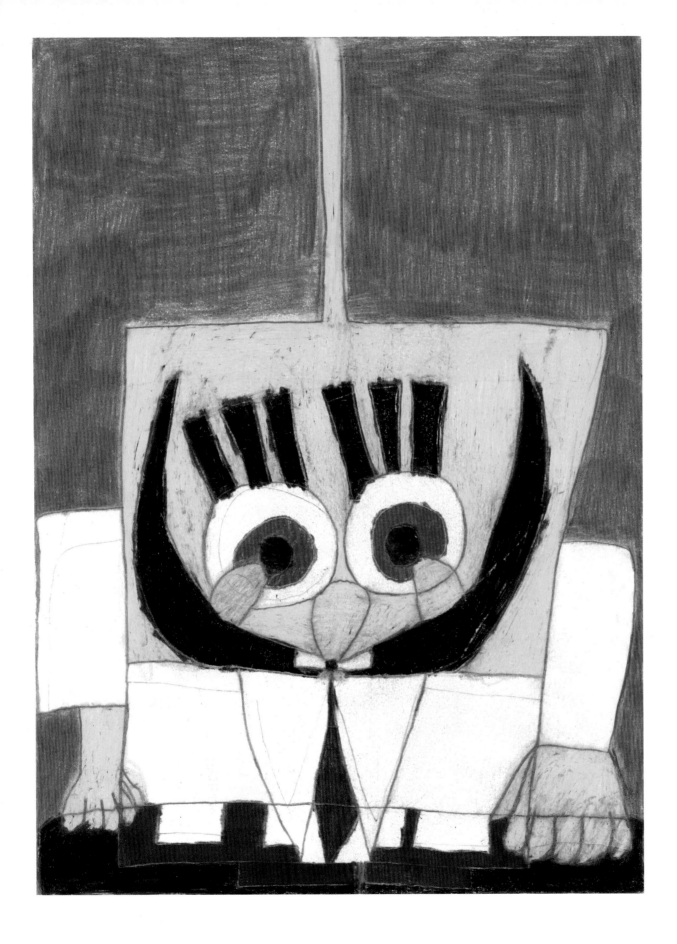

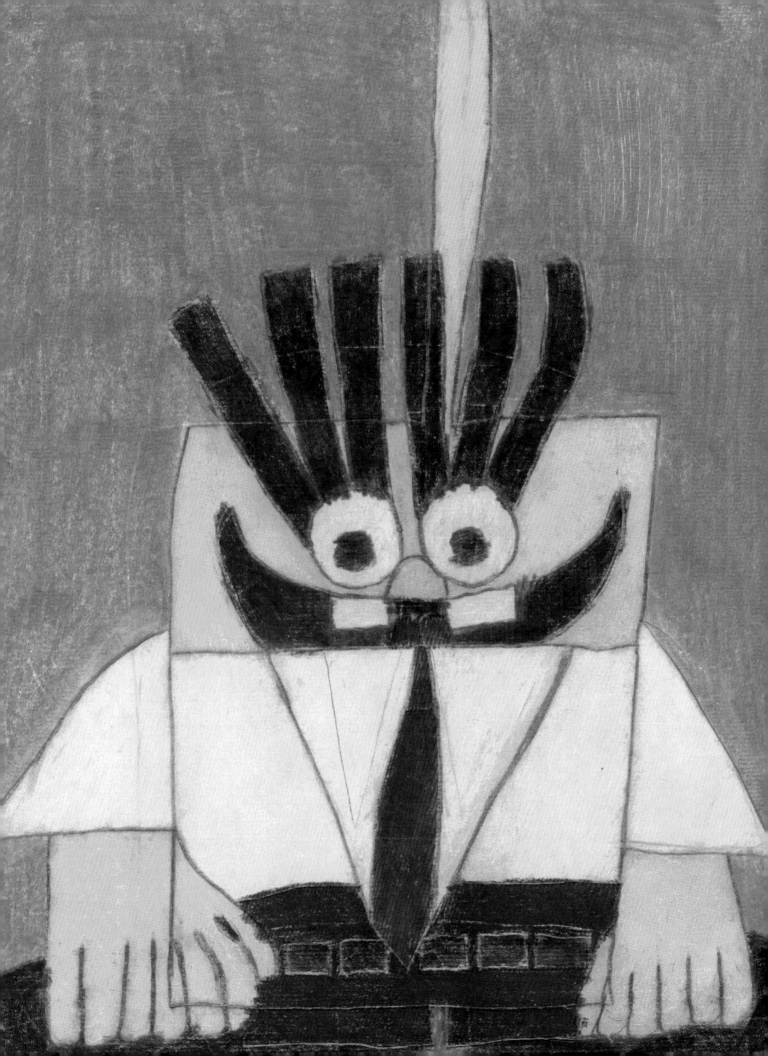

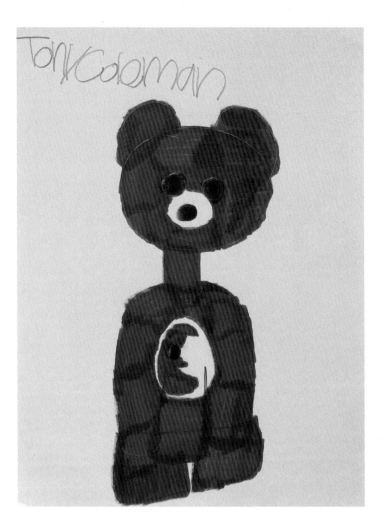

TonyColoman

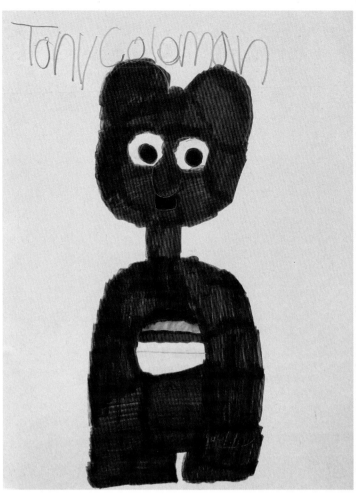

TonyColoman

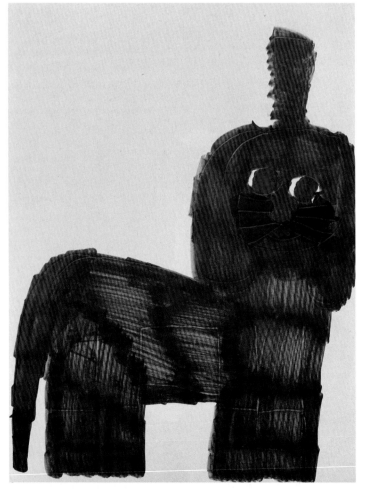

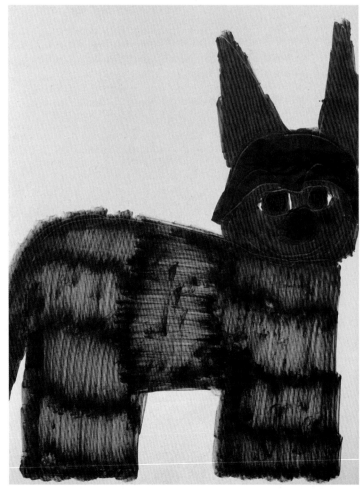

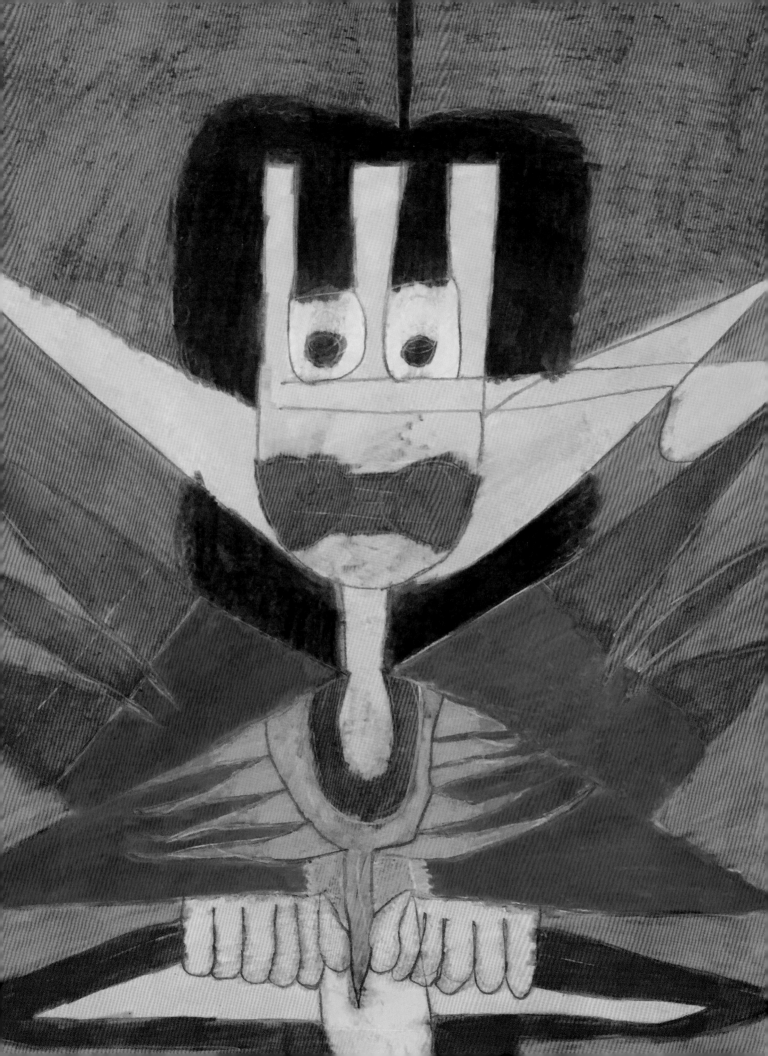

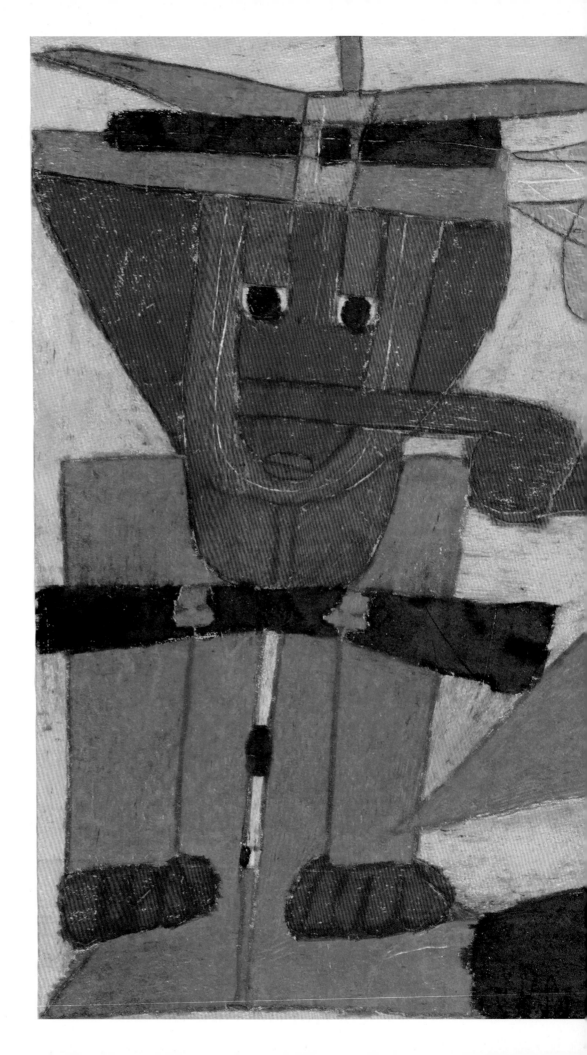

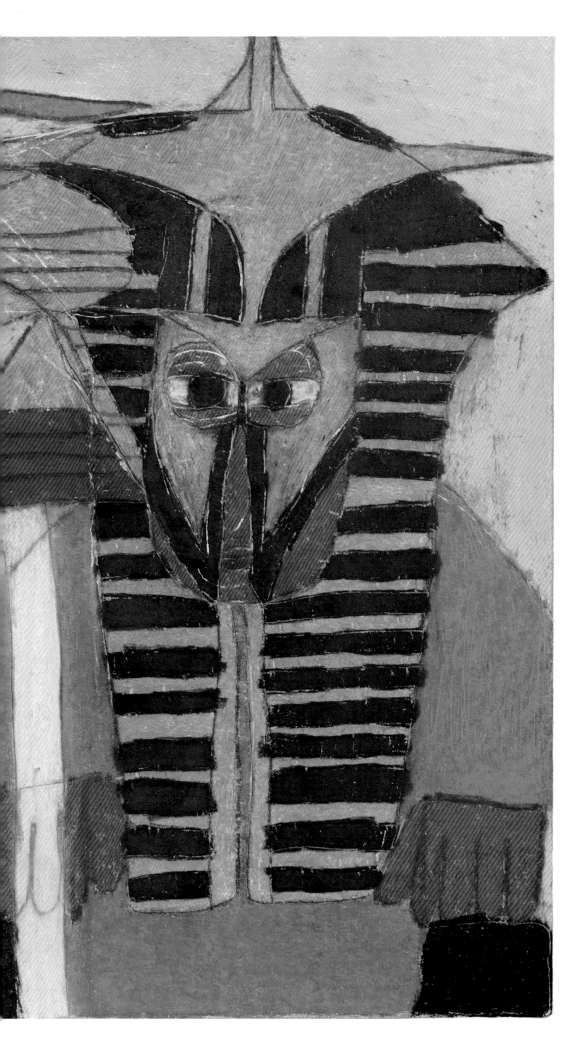

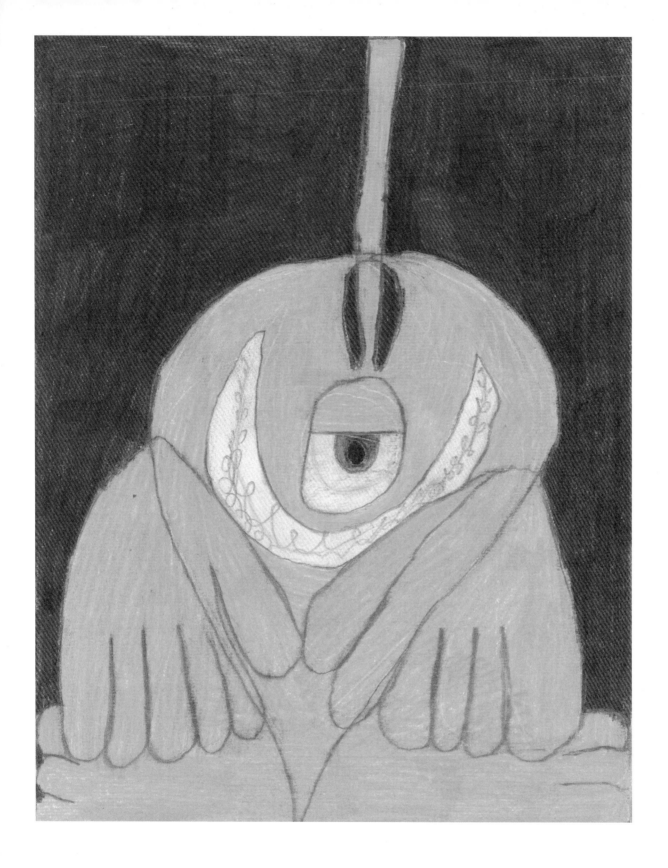

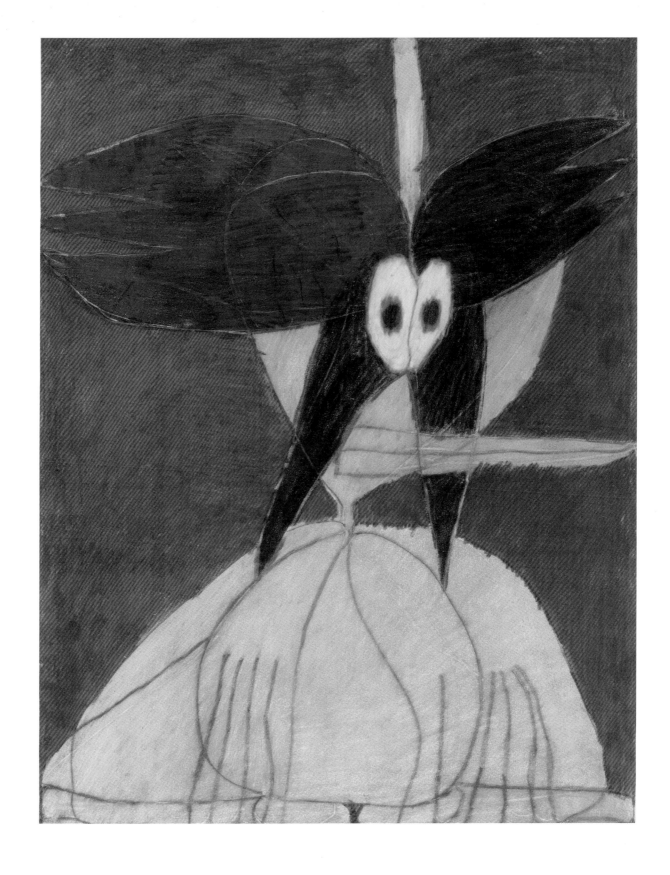

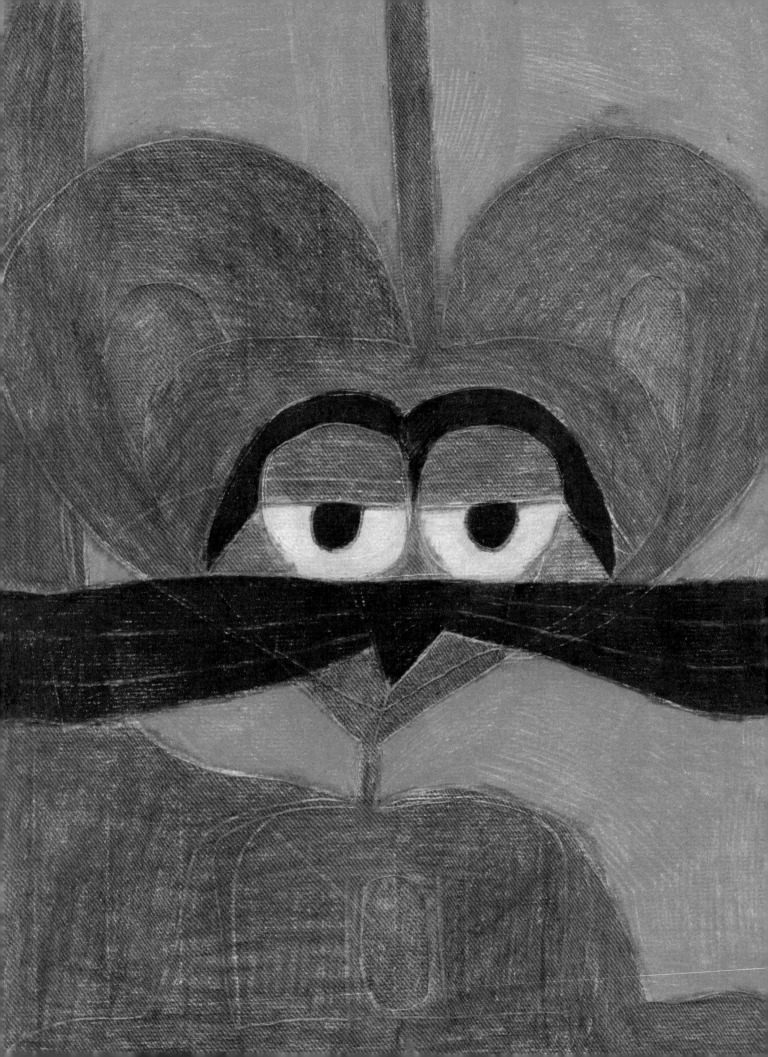

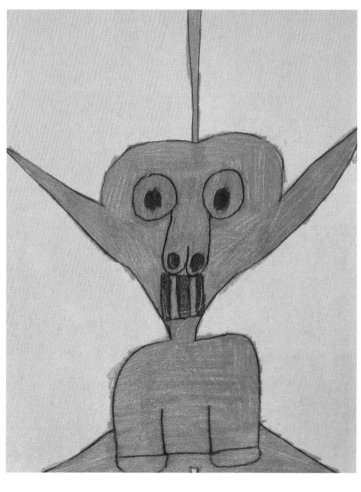 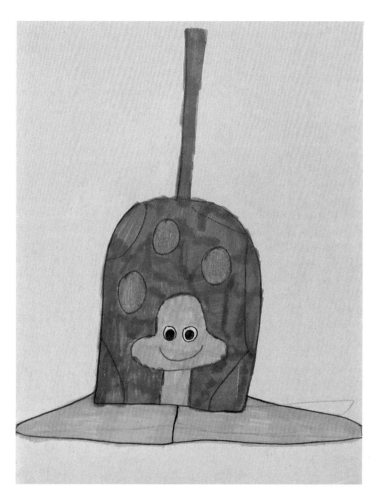

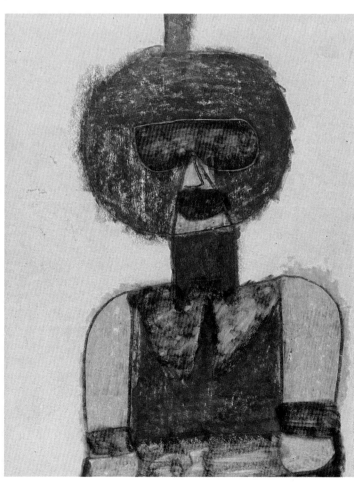 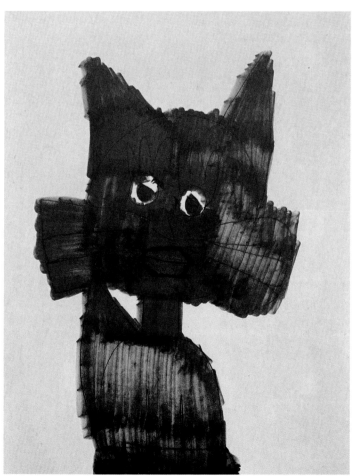

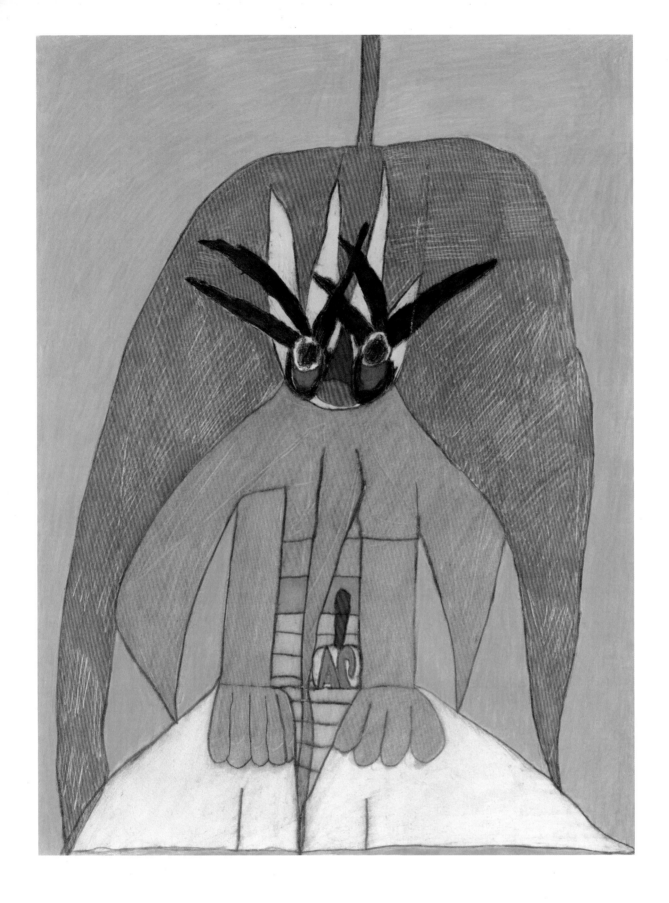

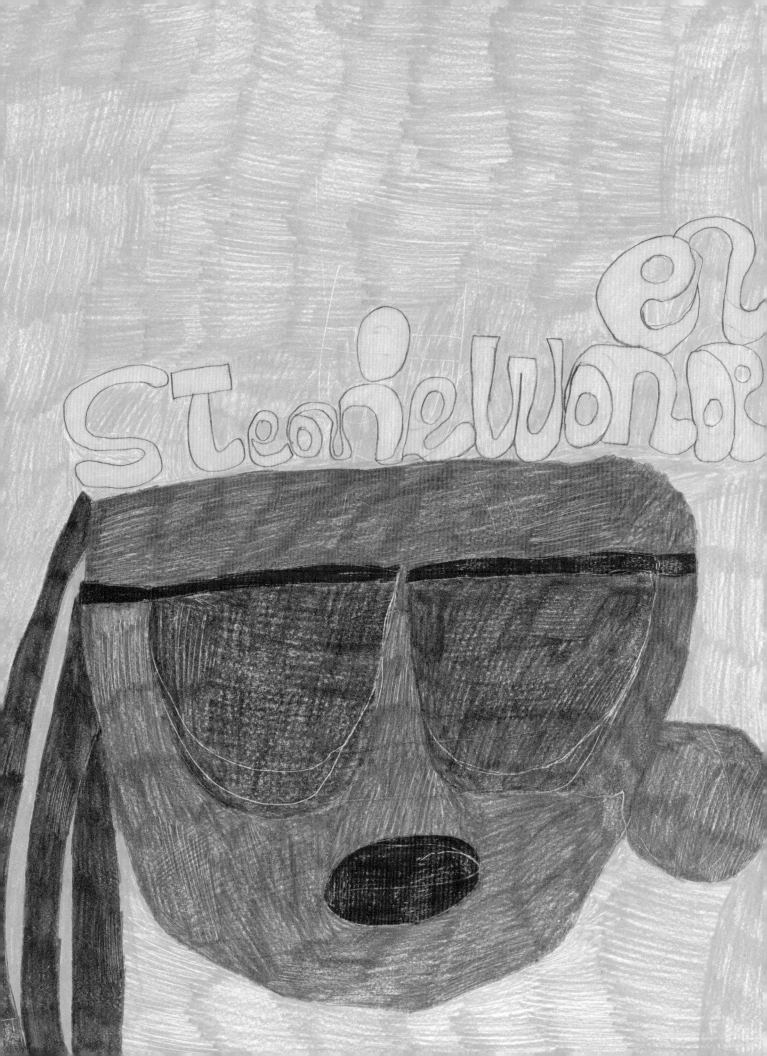

Index

Front Cover
Gumby On Pink
(2021)
22in × 30in

p. 2
Giraffe
(2020–2022)
11in × 14in

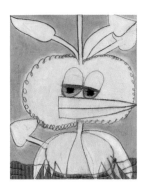

p. 3
Big Bird
(2022)
11 in × 14 in

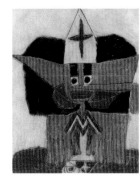

p. 4
Wonder Woman
(2022)
11 in × 14 in

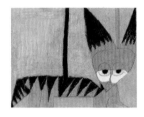

p. 5
Garfield On Pink
(2020)
11in × 14in

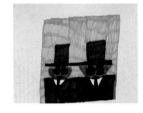

p. 6
Men In Black
(2014)
11in × 14in

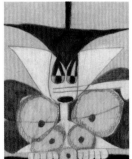

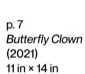

p. 7
Butterfly Clown
(2021)
11 in × 14 in

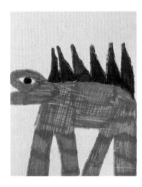

pp. 8–9
Killer Klowns From Outer Space
(2021)
11in × 14in

p. 10
Green Dinosaur
(2015)
6in × 8in

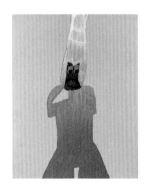

p. 10
Silver Wizard
(2017)
6in × 8.5in

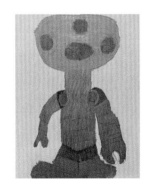

p. 10
Deep Sea Diver
(2017)
6in × 8.5in

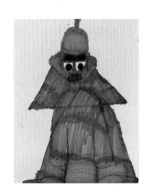

p. 10
The Statue Of Liberty
(2015)
6in × 8in

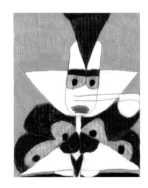

p. 11
Butterfly Clown From Felini's Clowns
(2020)
11in × 14in

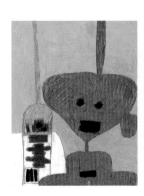

p. 12
R2-D2 & C3-PO
(2021)
11 in × 14 in

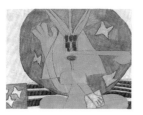

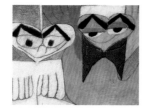

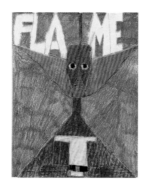

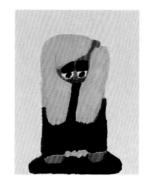

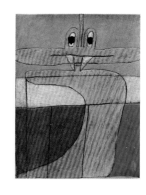

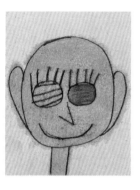

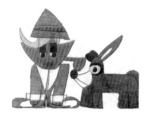

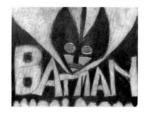

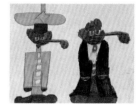

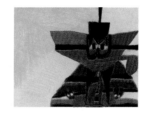

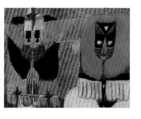

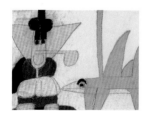

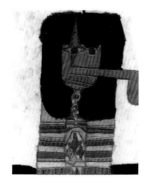

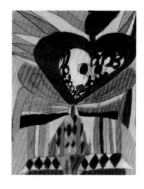

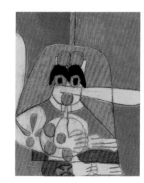

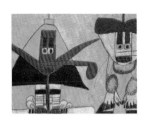

pp. 28–29
Lizzo & Siouxsie Sioux
(2021)
12in × 18in

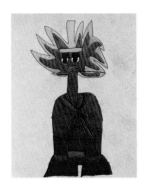

p. 30
Super Chicken
(2017)
6in × 9in

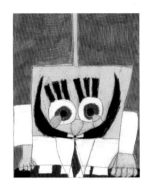

p. 31
Majin Vegeta
(2017)
6.5in × 8.5in

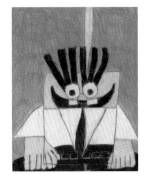

p. 32
Sponge Bob
(2021)
11in × 17in

p. 33
Sponge Bob
(2020)
11in × 17in

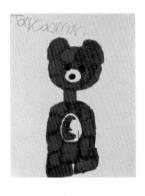

p. 34
Bed Time Bear
(2015)
6in × 9in

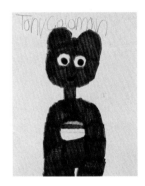

p. 34
Cheer Bear
(2015)
6in × 9in

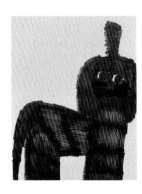

p. 34
Red Dog
(2015)
6in × 9in

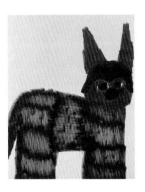

p. 34
Red Cat
(2015)
6in × 9in

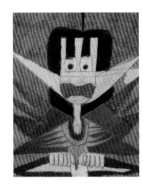

p. 35
*Model Wearing
Alexander McQueen*
(2021)
18in × 24in

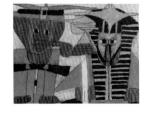

pp. 36–37
*Leprechaun & Afrika
Bambaataa*
(2022)
14in × 17in

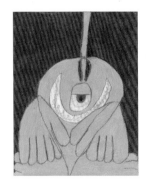

p. 38
Mike Wazowski
(2021)
11in × 14in

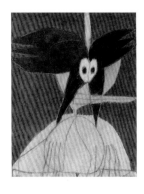

p. 39
Tweety Bird On Red
(2022)
18in × 24in

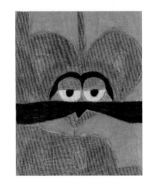

p. 40
The Pink Panther
(2020)
11in × 15in

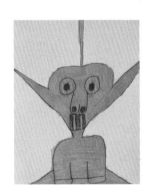

p. 41
Yellow Eyed Alien
(2017)
6in × 9in

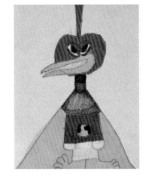

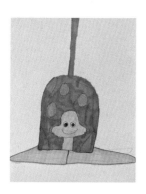

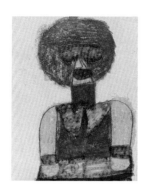

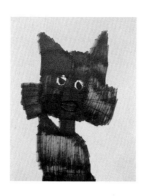

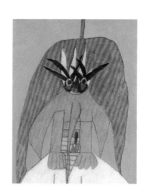

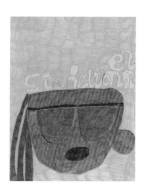

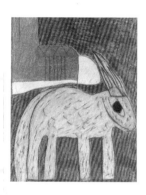

ANTHONY COLEMAN
Self Taught Artist
Born 1969

SOLO EXHIBITIONS

2023
New Drawings - AMANITA - New York, NY

2022
Ridgewood - Best Western - Ridgewood, NY
Philadelphia - Space 1026 - Philadelphia, PA
Miami - Dale' Zine - Miami, FL

2021
Roll The Dice - New Language - London, England
Call Me Tony - SAGE Gallery - Austin, TX

2018
First Friday - Crime & Punishment - Philadelphia, PA

2016
Current Work - Benna's Cafe - Philadelphia, PA

GROUP EXHIBITIONS

2022
Leigh Bowery & A Bottle Of 7-Up - Fleisher/Ollman Gallery - Philadelphia, PA
Body Work - SAGE Gallery - Austin, TX
Outsider Art Fair - SAGE Gallery booth - Manhattan, NY

2021
Now Now - Breach - Miami, FL
Onward 2.0 - La Luz de Jesus Gallery - Los Angeles, CA
The Nostalgia Show - SAGE Gallery - Austin, TX

2020
Home Makers - SAGE Gallery - Austin, TX
Shoe Show - Little Gallery - Philadelphia, PA

2019
Enorme - Eye Bodega - Manhattan, NY
Hot Loops - Little Berlin - Philadelphia, PA
Animals, People, Plants, Apartments - Space 1026 - Philadelphia, PA

2018
Pop-Up - Harpy Gallery - Brooklyn, NY

2017
New Work - Gallery Aferro - Newark, NJ

2016
Side By Side - Savery Gallery - Philadelphia, PA
On The Wall - Dirty Franks Off The Wall Gallery - Philadelphia, PA
Thing & Place - Collaborative Exhibition with Sinead Cahill - The Galleries at Moore - Philadelphia, PA